DIRECTOR'S CHOICE

THE AMERICAN MUSEUM IN BRITAIN

For Mark,
with warm wishes,
Richard

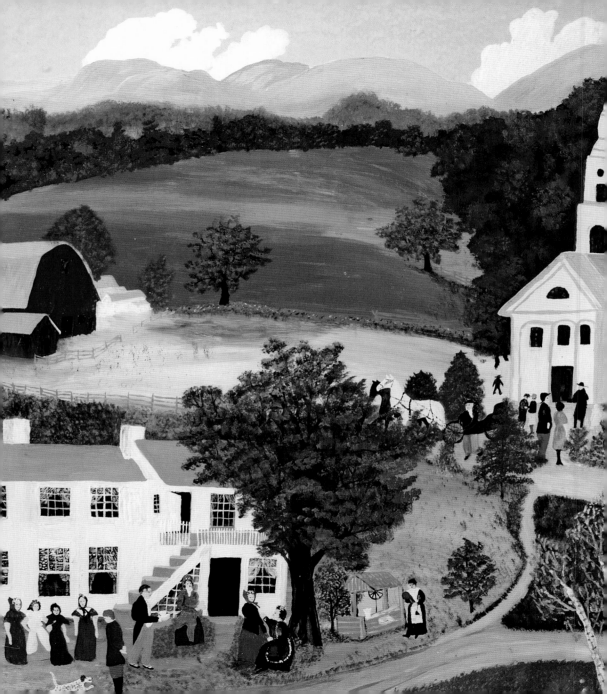

DIRECTOR'S CHOICE

Richard Wendorf

THE AMERICAN MUSEUM IN BRITAIN

SCALA

INTRODUCTION

THE AMERICAN MUSEUM IN BRITAIN was a unique institution when it opened its doors in 1961 and it remains so today: the only museum devoted to American decorative art that is located outside the boundaries of the United States. The Museum's mission has remained the same throughout its first half century, which is to increase knowledge of American cultural history in order to strengthen the relationship between the United States and the United Kingdom. Well over 3 million visitors have found their way to the Museum so far – the vast majority of them British – as the Museum pursues its educational programmes within its extensive suite of period rooms and through its special events and exhibitions.

America did not need another museum devoted to the decorative arts in 1961; its citizens were already well served by the collections at Winterthur, Shelburne, Colonial Williamsburg and a number of smaller institutions. But the American Museum's co-founders sensed a need as well as an opportunity. Taking a leisurely drive through New England in the late 1950s, Dallas Pratt (an American psychiatrist and heir to a substantial Standard Oil fortune) and John Judkyn (an English designer and antiques dealer) explored the possibility of creating an outpost of American culture abroad, not far from where Judkyn owned a manor house in Freshford, nestled in the beautiful Limpley Stoke Valley in Somerset. Here is how Pratt remembered this moment years later:

> No European museums with which we were familiar had moved period rooms, appropriately furnished, and sometimes entire houses, into settings designed to illustrate the 'way people lived' in particular places and times.
>
> At this stage, my desire was simply to share with the British the aesthetic charm of early American furniture and decorative arts and their historical background. John added a concern of his own: to inform the British…of the outstanding achievements in these arts and crafts, a subject about which he believed them to be woefully ignorant. There is a shade of difference here, between myself as collector and prospective museum exhibitor,

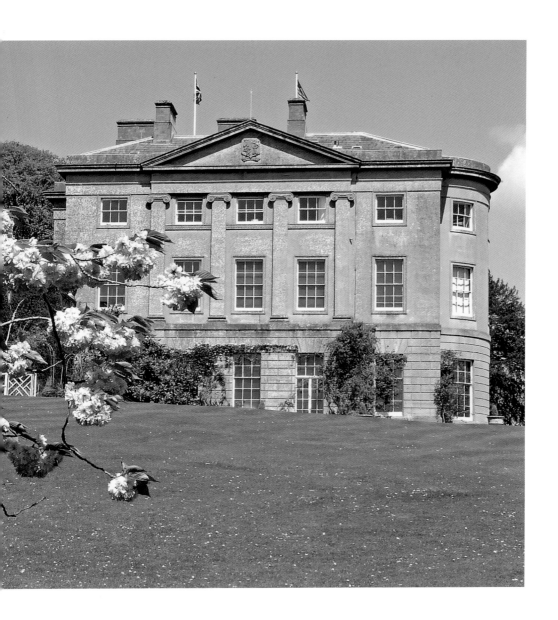

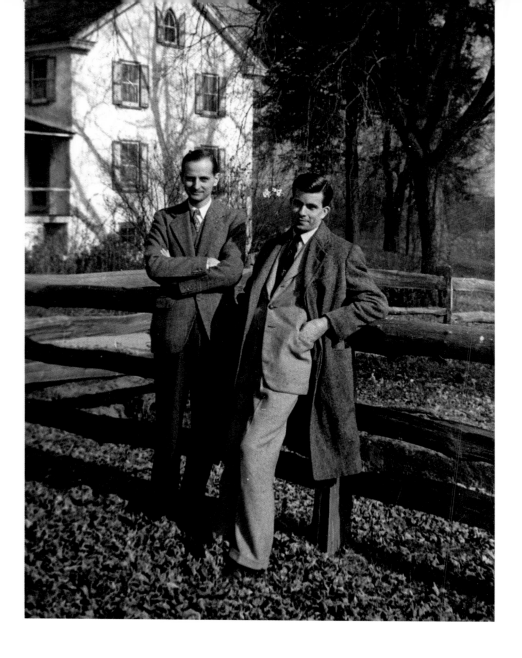

and John as educator and promoter of Anglo-American understanding. Both motivations merged in the outcome, a chronological sequence of historical rooms plus changing exhibitions at the American Museum, and the no less important educational programme, emphasising work with schools.

Judkyn and Pratt enjoyed the financial resources to make such a venture prosper. They were both collectors; they were well acquainted with the antiques trade in America as well as in England; and they surely must have seen such an ambitious project as a larger, more public reflection of their personal devotion to each other. Once launched on their new enterprise, they pursued it with remarkable zeal, purchasing Claverton Manor on the outskirts of Bath, recruiting their friend Ian McCallum as the first director, engaging the gifted Nick Bell-Knight as their master renovator and collecting (largely through purchase) almost 2,000 objects – all within the space of two and a half years.

The Museum's collections have grown to include 11,000 items, but all of the features that Judkyn and Pratt believed to be essential to their joint venture remain core elements of the institution today. The manor house they lovingly restored – and then adapted for museological purposes – remains a central showpiece all by itself, its neoclassical design blending effortlessly with some of the most beautiful views in England. Sir Jeffry Wyattville's Palladian architecture serves as an interesting foil, moreover, to the procession of period rooms that range from 1690s New England to a New Orleans bedroom dating from just before America's brutal civil war. Only in the Greek Revival Room do the pieces of American furniture and other decorative arts mesh perfectly with the contemporary setting of the manor house's principal sitting room. Judkyn and Pratt wanted the rooms to appear as if their inhabitants had just stepped out the door for a moment – and they insisted on modest and even humble tableaux as well as rooms that are more elegant and refined.

The design of the Museum's period rooms has remained essentially the same, although they are continuously refreshed based on the acquisition of new objects and of more precise historical information. Only one room has been added, the space devoted to trade with China, with its collection of Asian porcelain and paintings. Conkey's Tavern – rescued from Pelham,

Dallas Pratt and John Judkyn in America, *c.*1940.

Massachusetts – remains in the Museum's lower level, although the rest of the space there has recently been transformed into an interactive introduction to American history, with a strong focus on Native American and African-American cultures. The estate still retains its replica (or, as I explain later, its 'version') of George Washington's garden at Mount Vernon, even as the property under the Museum's care has grown to 125 acres. A separate exhibition gallery, with a library and storage facility located beneath it, opened in 1989, and the Museum's golden anniversary in 2011 saw the opening of the new Folk Art Gallery and of the lecture theatre and education centre created in the estate's Stables and Coach House.

To the residents of Somerset – and especially to our neighbours in the villages of Warleigh and Claverton – the Museum's schedule of events is synonymous with the roar of cannon fire as the institution hosts its annual historical re-enactments, pairing Red Coats and Patriots, the French and the Indians, and the Union North and Confederate South. But the Museum's schedule of events is actually quite varied, ranging from lectures and concerts to workshops and quilting bees. Children continue to arrive with their teachers throughout the school year, and we have recently harnessed various technologies to bring the Museum to the schools and visitors to our website. Important as these programmatic initiatives have become, the American Museum remains focused on the items in its collections, the vast majority of which are always on view. One of our former colleagues, John Huitson, framed the argument for the historical contextualisation of these objects in a particularly prescient way over 25 years ago:

> Here, in a society which appears so often to be obsessed with consumer goods, disposable articles and cheap imitations, is an authentic message transmitted through the Museum's collection of original objects. By emphasising such basic concepts as quality, form, material and function, which have tended to be smothered by contemporary society's technological development, the Museum helps to preserve the human being's capacity to look constructively at objects, to experience beauty which may not be bountiful in the home environment, and to redefine standards in an age of mass production. At the same time, by displaying most of the exhibits in their historical-cultural context, the Museum

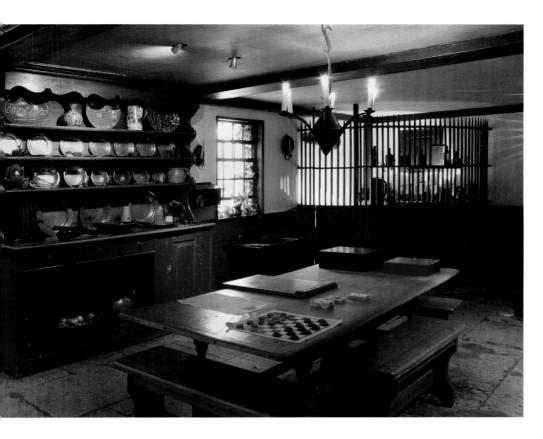

Conkey's Tavern, *c.*1776.

helps to present something of the richness, complexity and diversity of American history.

The essays in this volume attempt to pay tribute to these objects and to this historical matrix. They are meant to be exploratory and personal as well as critical in their demeanour. I thank my colleagues for generating the research their director has gratefully been able to draw upon, and I ask for their indulgence when my own methodologies and enthusiasms don't perfectly mesh with theirs.

Beatrice Benjamin Cartwright, 1943

Reynaldo Luza
Lima, Peru 1893–1978
Pastel and gouache on paper, 78 x 102.5 cm
Dallas Pratt Archive
DP2007.4

The fortune that enabled the American Museum's founding fathers to realise their collective aspirations came from Dallas Pratt's mother, Beatrice Benjamin Pratt. Beatrice inherited her substantial fortune from her maternal grandfather, Henry Huddelston Rogers, one of the legendary Standard Oil magnates of America's Gilded Age. A fortune based on liquid gold supported Beatrice throughout her adventurous life, which included four husbands (Pratt, Gibson, Cartwright and McEvoy), numerous houses (in New York, Newport, London, France and Florida) and a continuous swirl of parties and the jewellers and couturiers who pampered her. Dallas remembered his mother to have been happiest when 'splendidly dressed and covered with jewels, sailing into a gala occasion accompanied by an entourage – all heads turning'.

This billion-dollar princess was often captured by the paparazzi of her era, but I find her most memorably revealed in this haughty and haunting pastel-and-gouache portrait by Reynaldo Luza: haughty because of that set mouth and the sitter's refusal to engage us directly; haunting because of the way in which her shadowy eyes suggest sadness as well as a certain detachment. Trained as an architect, the Peruvian-born Luza began his successful career as a fashion artist in New York City, illustrating the sumptuous glossies of his day. Here we find him skilfully setting off what seriously mattered in Beatrice's life – those fire-engine-red lips and nails, those extraordinarily large emeralds – against the almost diaphanous nature of her clothing. The iconic attributes have changed, but Luza presents her in the centuries' old tradition of imperial portraiture, ready at any moment to raise that elegant left hand and beckon us to her.

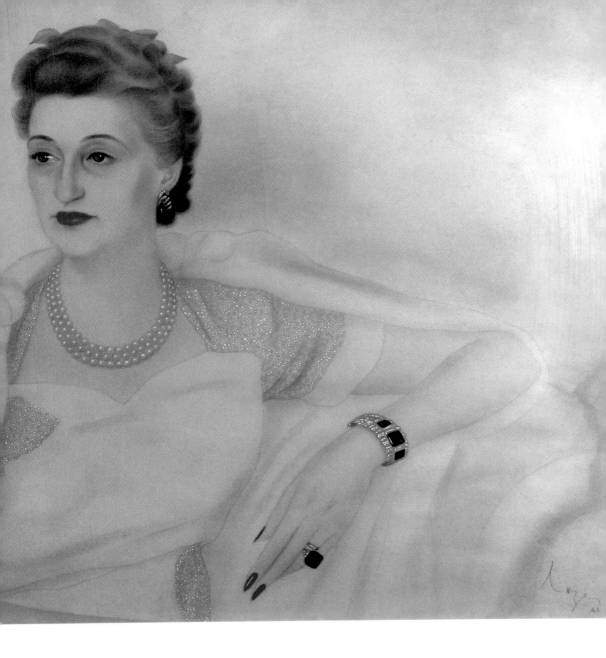

BEATRICE BENJAMIN CARTWRIGHT | **11**

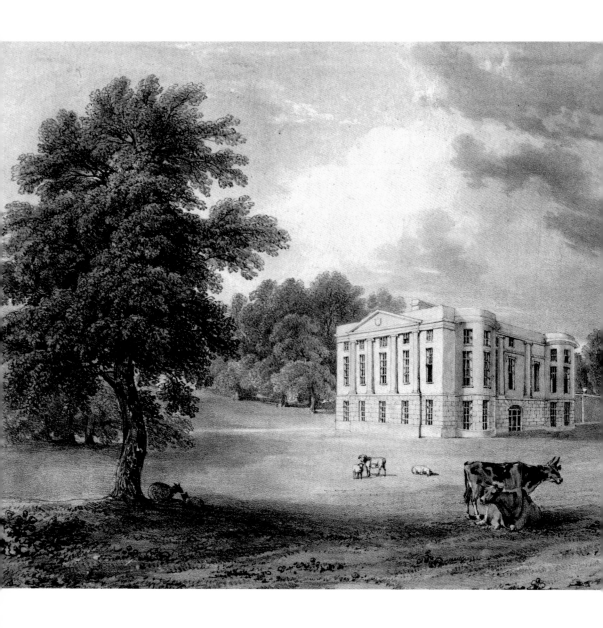

*Claverton Manor, c.*1825

Lithograph on paper, 30.5 x 38.7 cm
Museum purchase, 1991
1991.168

THE ORIGINAL MANOR HOUSE stood in the village of Claverton, directly below where the current house stands today, appropriately situated near the parish church, the grave-yard and the other central features of village life. When it fell into disrepair early in the nineteenth century, John Vivian and his family decided to build a new house on Claverton Hill, where the air was fresh and the views of the Limpley Stoke Valley were unparalleled. Vivian chose Jeffry Wyatt as his architect, which was a safe choice given Wyatt's alterations and extensions to several important buildings in the area, includ-ing Badminton House and Corsham Court, and similar work for many years at Chatsworth in Derbyshire. Wyatt had already designed several private houses and he worked comfortably in the Palladian style as it was practiced in Britain, with its sym-metry, central hallway, grand spiral staircase, classical ornamentation and glowing Bath stone, which was quarried nearby at Claverton Down. Wyatt changed his name to Wyattville later in the decade and was subsequently knighted by George IV, for whom he carried out extensive alterations at Windsor Castle, where he died in 1840.

When the founders of the American Museum discovered that Claverton Manor was on the market in the late 1950s, they also discovered that it, too, had fallen into disrepair, as had so many other country houses during and after the Second World War. Their first challenge was therefore to bring the house itself back to life. Once that was accomplished, their colleague Nick Bell-Knight could begin the arduous task of trans-forming these grand spaces into a series of humble as well as elegant Colonial and Federal period rooms, thus creating the unusual interplay between what is British and what is unmistakably American.

Mount Vernon garden,
1961 to the present day

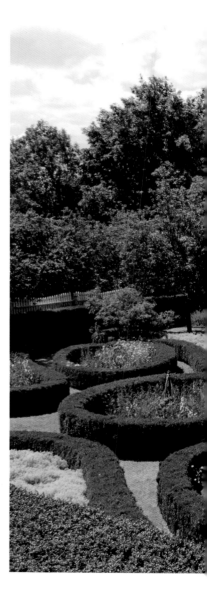

THE FRISSON BETWEEN AMERICAN objects and an English setting extends beyond the manor house itself to the Mount Vernon garden, which is located behind the Coach House and Stables. This replica of George Washington's upper garden at his estate on the Potomac River was not an afterthought, but rather part of the founders' comprehensive vision of their new enterprise. The garden that had previously existed in this space was completely excavated and new beds and borders were laid out perfectly to scale. A white picket fence encloses almost half of the garden and a replica of Washington's school house (also used for the storage of seed) completes the view.

Well, almost completes the view. Like museums, gardens are organic entities – literally so – and thus there are several interesting ironies at play here. To begin with, Washington's gardens in Virginia would have been heavily influenced by English models and possibly even laid out by the English themselves. Our garden, moreover, was based on the state of Mount Vernon's in the late 1950s, which (recent archaeological research informs us) may not have accurately reflected the gardens Washington himself knew. In addition, our garden has evolved over the past five decades as well, but it could never have been a perfect replica of Mount Vernon's because of differing climates and gardening techniques. Some flowers grow there that don't flourish here – and vice-versa. The clipped practice of English gardeners has produced hedges that are invariably straight, whereas the Colonial practice was to thin the box, giving the hedges a moulded or plucked appearance. Our Mount Vernon garden is therefore a cultural hybrid: part American, part English, lying just beyond the cherry trees that cloak the lawn with their pink petals each spring.

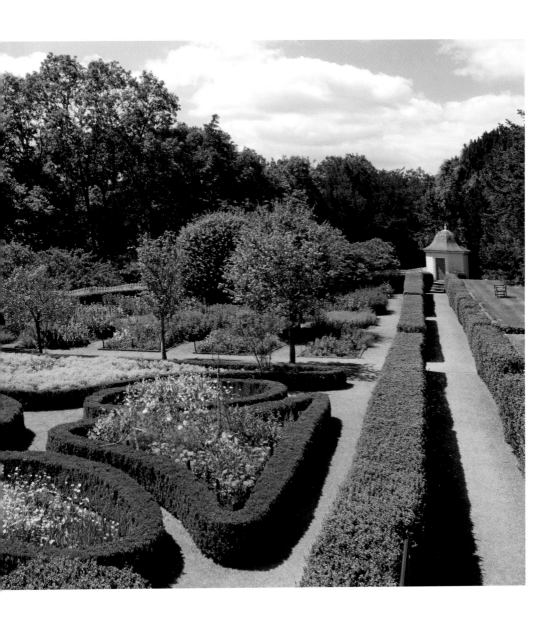

Thoughts on the Decorative Arts

As with our understanding of 'folk art' (which I shall examine later), discussions and definitions of the 'decorative arts' have long been contentious and often misguided. The historical and implicit comparison is with the 'fine' arts, especially paintings, prints, drawings and statuary. There is a strong hierarchical distinction embedded in this centuries-old formulation, as if the decorative arts somehow serve as modest handmaidens to the more divine or cerebral artistic forms. According to this deeply ingrained view, an artist produces a painting whereas an artisan produces the frame, an object that serves the picture as a protective barrier and enables the owner to affix it to her wall. Such a distinction disregards the fact that most painters have a clear idea of how their pictures should be framed, often designing the surrounds themselves and, in some cases, even producing them with their own hands. The 'fine' in the 'fine arts' derives, in its long linguistic history, from the Latin root for being highly 'finished', and traditionally the frame serves precisely this purpose, not only bringing the artistic process to a proper conclusion but also, in many cases, standing as a work of art in its own right.

This distinction between the decorative and the fine arts – between the frame and the painting it

George Washington, 1800–25

(After) Gilbert Stuart
Saunderstown, Rhode Island 1755–1828
Boston, Massachusetts

Oil on canvas, 30.5 x 25.4 cm

Gift of Hugh and Francis B. Richards, and Mary Dorothea Colley, 1999

1999.179

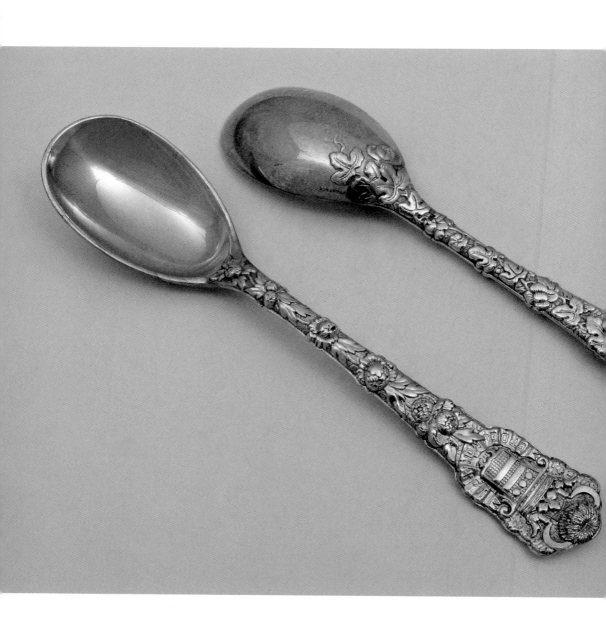

complements – is based on the traditional view that decorative items have been produced largely for a practical purpose, that they are intended to be put to use. One sits on a chair, eats with a spoon, pulls a quilt over one's bed at night, whereas a bronze bust of one of the founding fathers is to be studied, discussed and admired for the ways in which it raises questions about historical character, the human figure and our notions of integrity and beauty. There are clearly significant cultural and aesthetic differences between these two ends of the spectrum, but even more important is the way in which private domestic interiors and public museums alike have pushed these potentially opposing poles towards a central meeting ground. Paintings and statues, after all, were meant to be put to use, and not just those images that were intended to be worshipped for spiritual (or secular) purposes. They were often meant to be placed in a specific setting for a specific purpose, and it was not unusual for a painter to be asked to produce a picture of a specific size and shape – an oval, for instance – so that it would form part of a room's larger decorative scheme.

Items of decorative art have, by the same token, usually evolved towards a less primitive, more highly elaborate and 'finished' state. A simple Colonial-era spoon made of pewter stands in stark contrast to the gilded silver spoons produced by Tiffany and Company as part of a large service commissioned by the mining magnate John William Mackay. Walter Benjamin and other theorists have speculated about that moment when an object made for daily use (a watch, a chair, a spoon) passes over a threshold and becomes something that is cherished and admired for its own sake – becomes a 'collectible', in other words. Benjamin calls this transition from the realm of the

Two silver parcel gilt egg spoons, 1878

TIFFANY AND COMPANY, designed by EDWARD C. MOORE
1827–1891 (active New York City)
Cast silver gilt, 12.8 x 2.7 cm (at widest point)
Gift of John William Mackay III, 1983
1983.184

ordinary – of practical utility – a release from the bondage of being useful. This cultural transformation takes place each time a private individual or museum curator chooses an object to be placed in the realm of the collected – but it also occurs each time a jeweller, cabinetmaker or silversmith begins to design and produce an object that is intended to please, fascinate and flatter, even though it can also be put to practical use.

This emphasis on how a utensil or piece of furniture can be made more elaborate, more highly decorated, more expensively 'finished' has led, in turn, to the naïve (or at least the popular) view that the decorative arts are just that – items that are not essential, objects that have been produced simply to please the eye, to complete the setting of a table or to complement the formal design of a room. What may seem to be superficial to one person, however, is often viewed by others as part of a significant cultural paradigm: not necessarily a scheme to be emulated or praised, of course, but certainly one to be studied within its historical context and as an example of the material culture of a given period.

This is why the decades-old American interest in 'period rooms' has had – and continues to have – such an important influence on how American art is displayed. Period rooms integrate a variety of elements into a more or less coherent whole, ranging from the simplicity of the American Museum's Colonial settings to the refined elegance of a residence in Baltimore or New York. The succession of such rooms and their collections is crucial, moreover, to an understanding of how tastes change, thereby reflecting how deeper cultural shifts take place as well. The fabric illustrated here, probably created around 1876, suggests that it was produced for a clientele that could not afford to decorate its walls

Printed cotton fragment, *Washington – Justice and Peace*, mid-19th century

AMERICAN PRINT WORKS
1835–1879
Fall River, Massachusetts
Printed cotton, 55 x 49 cm
Bequest of Dr Dallas Pratt, 1994
1959.170.3

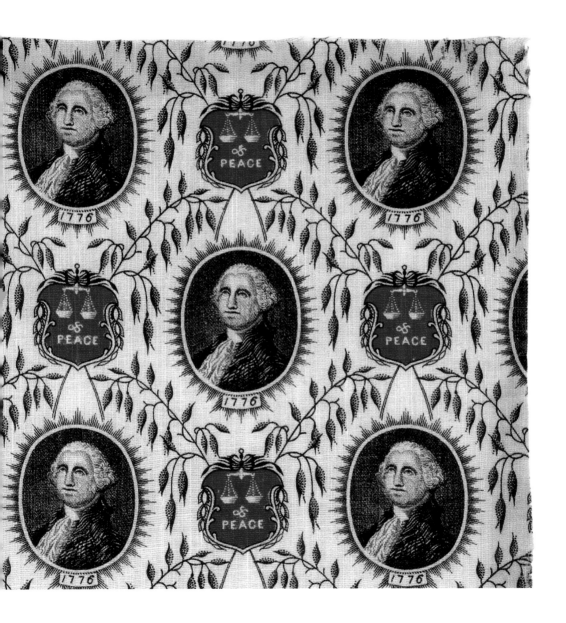

with original works of art; but it also reflects that moment when humble but proud Americans could celebrate the one-hundredth anniversary of the founding of their republic. If we compare this decorative motif with the French-style wallpaper that preceded it near Baltimore (illustrated here), we can begin to sense some of the social, geographical and ideological changes and tensions that helped to define such a loosely knit confederation.

The relationship between the decorative and the fine arts has therefore become one of reasonably comfortable bedfellows rather than one of modest handmaiden to elevated genius, with talent and knowledge – as well as skillful execution – essential to both. Both contribute to a room's décor – a French word, now thoroughly Englished, that derives, like 'decorative' itself, from the Latin word for 'beauty'. Today these congenial bedfellows continue to compete as rivals only in the sense that they vie with each other for pride of place in the contemporary art market.

Corn-motif wallpaper, Deer Park Parlor,
1790–1820

Baltimore County, Maryland
Printed in the 1950s from 18th-century blocks

Greek Revival Room, *c.*1820

New York City

MANY OF THE PERIOD ROOMS in the Museum were imported lock, stock and barrel – which is to say, walls, floors and furnishings – from their original houses on the eastern seaboard of the United States. This particular room is rather different in two important ways. In the first place, it has been imaginatively designed by drawing upon an assortment of neoclassical elements and pieces of furniture from various venues that, taken together, evoke the American interest in the 1820s and 1830s in what is now called the 'Greek Revival' style. This recreation of a neoclassical room has been facilitated (in the second place) by the fact that the spacious drawing room at Claverton Manor in which it resides dates from the same period and would, presumably, have been furnished with similar objects (of English, French or Italian design) in the 1820s. The dentil pattern in the original cornice work in this room, for example, is identical to that found in the Hopper House, built around 1836 at 110 Second Avenue in New York. The marble chimney-piece with its elegant caryatids, which

was transferred from another room in the manor, is almost identical to those found in several New York houses of the period, including the Fiedler House on Bond Street. The room's bay windows can still be glimpsed in New York today by walking (attentively) across Sixteenth Street. It is therefore only fitting that the major pieces of furniture on display here – the six Sheraton-style side chairs, the Empire-style sofa, the card table and the case on the American piano – are all attributed to Duncan Phyfe, the Scottish-born cabinetmaker whose elegant work is synonymous with the finest furniture produced in New York during this

period. Opposite the bay windows, two fluted columns have been installed (based on those found in the Hopper House) and the swathe of mirrored glass placed between them virtually doubles our sense of the room's dimensions. Rather than having just left the room, the inhabitants have recently returned from the theatre and will soon be dining here to the accompaniment of the piano, flute, harp, clarinet, guitar and brass flute.

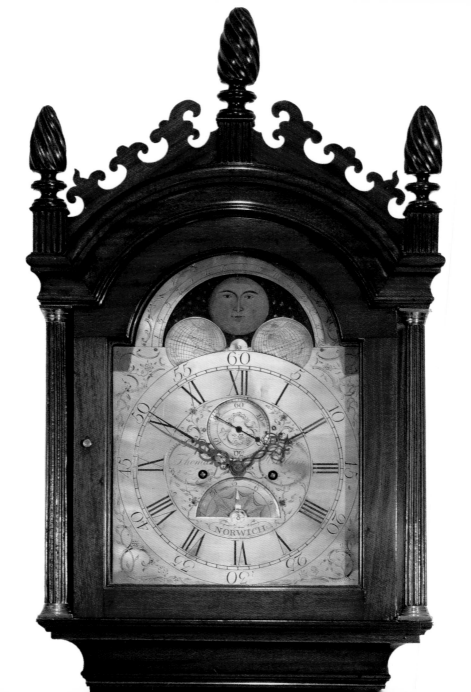

Longcase clock, 1770s

THOMAS HARLAND
London 1735–1807 Norwich, Connecticut

Mahogany wood, 233.7 x 48.3 x 25.4 cm

Bequest of Esther Gilbert, 1991

1991.152

THOMAS HARLAND stood at the very fountainhead of American clock making. Immigrating to Connecticut from his native England in 1773, he was a pioneer in using standardised and interchangeable parts as he constructed his longcase clocks, of which this is a superb example. Harland trained Daniel Burnap, who in turn trained Eli Terry, who is credited with establishing the first clock factory in America around 1800. The American Museum's clock measures 91 inches in height and is a particularly elegant piece of furniture. The twisted mahogany finials at the top of the clock sit on fluted wooden columns, which are then echoed in the classical wooden columns – also fluted – that appear to support the elements above them. I find the elaborate hour and minute hands and the fretwork between the finials to be rather fussy, belying the simplicity of the overall design. But Harland was almost certainly responding to the relative austerity of earlier English and American clocks, adding the applied decoration and centred carving near the bottom of his clock as well. The brass dial has been silvered, lacquered and intricately carved, with a secondary dial at twelve o'clock and two complications: the moon phase and the day of the month. The Museum's co-founders, John Judkyn and Dallas Pratt, visited the dealer Walter Gilbert in Norwich when they were collecting on the new institution's behalf, and Gilbert's daughter, Esther, promised to bequeath it to them. Pratt was especially keen to have the clock on view when the Museum opened in 1961, but Miss Gilbert was both adamant and true to her word. The clock arrived precisely 30 years later, following her death, and it was well worth waiting for.

Highboy, 1760–75

Possibly carved by NICHOLAS BERNARD
Philadelphia, Pennsylvania

Mahogany wood, 228.6 x 106 x 54.6 cm

Gift via Halcyon Foundation of Henry Francis du Pont, 1961

1961.1

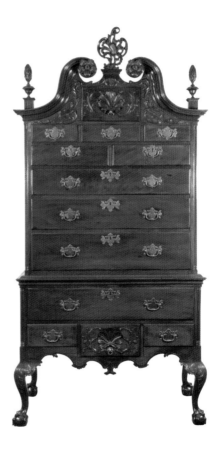

THOMAS HARLAND was not working in a cultural vacuum as he created his handsome clocks and cases in rural Connecticut. The third quarter of the eighteenth century marks one of the greatest eras of American design and craftsmanship, and nowhere can we see this more vividly than in the production of beautifully proportioned high chests in Philadelphia and Maryland. Leaving the somewhat squat baroque designs of Queen Anne and the early Georges behind them, these master craftsmen created what one dealer felicitously called 'richly carved rococo towers of mahogany'. The American Museum's elegant high chest was presented to the institution's co-founders in 1961 by their friend Henry du Pont, the master of Winterthur, because he believed that 'the highboy… is an American development not paralleled in English furniture'. This superb chest, possibly carved by Nicholas Bernard, stands almost exactly as high as Thomas Harland's clock, and it offers a virtual inventory of decorative elements that he could have drawn upon: a bonnet top with finials on the corners carved in the form of flames arising from urns; a central finial in the shape of a pierced cartouche; moulded and scrolled cornices bracketing the cartouche; a carved shell on the central drawer at the top of the chest, flanked by foliage in low relief; a similar drawer at the very bottom of the chest, where the stiles have reeded columns; brass handles in the shape of bats; and legs that begin with knees carved in the form of acanthus leaves and culminate in claw-and-ball feet. But such a description misses the central point, of course, which is that this exquisite chest counterbalances both its size and the utility of its 13 drawers through its perfect proportions and the supple refinement of its individual features.

Candle stand, *c.*1850

MOUNT LEBANON SHAKER COMMUNITY
Mount Lebanon, New York

Cherry wood, 64 x 40 cm diameter

Halcyon Foundation purchase from Faith and Edward Deming Andrews, 1959

1959.75

It would be difficult to imagine a more dramatic contrast with a Philadelphia high chest than this simple candle stand, carved from cherry wood in upstate New York almost 200 years ago. It is often called a 'light' stand – light in weight, light in design, meant to support a light – and it has an impeccable provenance. It was sold by members of the Second Family in Mount Lebanon to Faith and Edward Deming Andrews, whose publications and exhibitions largely generated American interest in the celibate Shaker brothers and sisters and their unusual aesthetic. The American Museum's co-founders were drawn to the Shakers' superb crafts-manship as well as to 'the simplicity, beauty of form and suggestive resemblance to modern themes in furniture design' that Dallas Pratt found in the pieces they purchased. Simplicity of form and utility of design are obviously the central elements at play here, but what is simple and useful can also be reasonably unattractive. The other key lies in the fusion of geometrical motifs and the imaginative handling of the 'join' itself. This candle stand consists of only seven pieces, but like the oval

boxes for which the Shakers are so famous, it fuses straight, round and elliptical forms into an unusual and yet harmonious whole. The 'fingers' on the oval boxes are thinned down as they taper and are then discreetly glued down, complemented by the tiny and yet distinctive nails that are both functional and decorative, subverting the eye from the actual join that lies beneath them. The join between the candle stand's round top and tapering support is not visible except by examination from below, and the three crescent legs disappear entirely into the column itself. In each case there is something enigmatic or even magical at work here – a sleight of hand and eye, as it were – although the Shakers would certainly have used a different word to describe it.

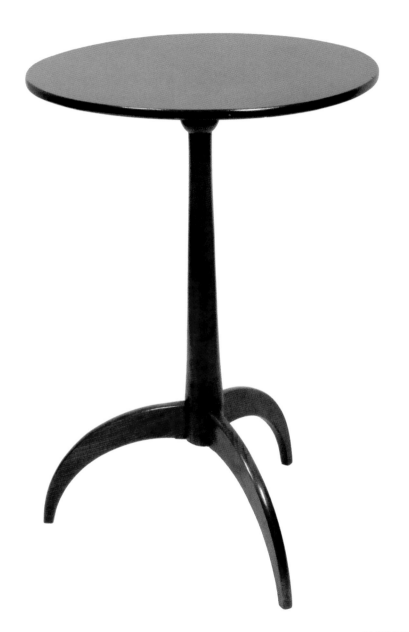

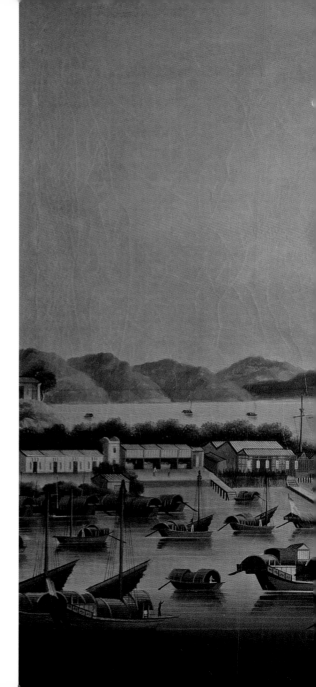

View of Canton, *c.*1850

CHINESE SCHOOL

Oil on canvas, 44.5 x 58.4 cm

Gift via Halcyon Foundation of Dr Dallas Pratt, 1993

1993.174

AMERICAN TRADE WITH CHINA represented one of the major commercial and cultural phenomena of the late eighteenth century and throughout much of the nineteenth. The original obsession in the West – in England and Europe as well as on the eastern seaboard of the United States – was with tea, over which China held a virtual monopoly until the British persuaded its colonies in India to cultivate it in the middle of the nineteenth century. And what began with the tea leaves themselves soon spread to all of the accoutrements associated with tea and its rituals: inlaid and lacquered caddies in which to store it, the porcelain pots and cups from which to serve and drink it, and eventually the silks and satins that one could wear to enjoy it. Pictures such as these two oil paintings documented and inherently celebrated this bustling mercantile world with its docks, hongs (warehouses), harbours and clipper ships. The various flags on the ships in the second painting indicate just how competitive this new business enterprise had become, with standards being raised by the Americans, the Dutch and Britain's East India Company (and by the French, Spanish and Russians in another of our paintings).

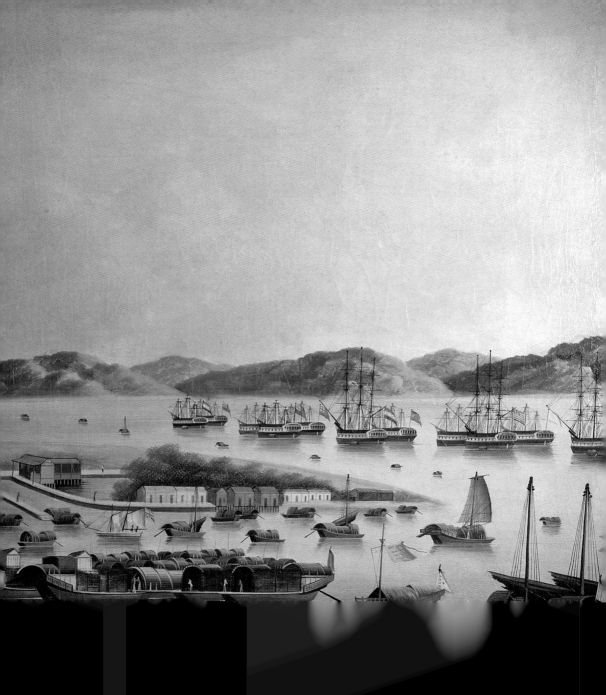

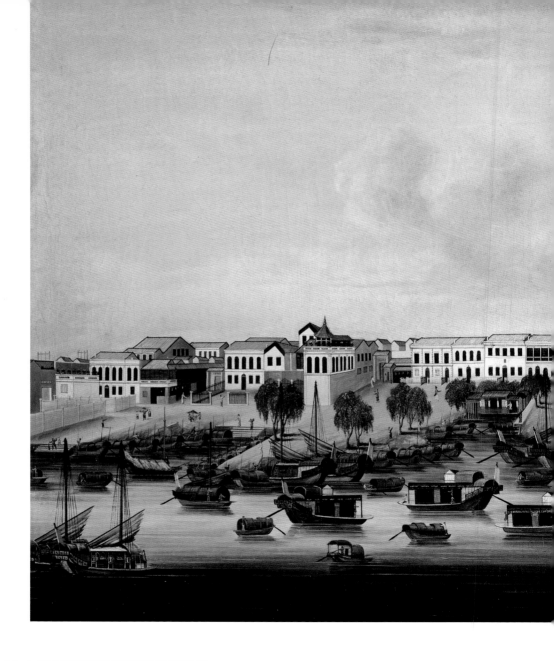

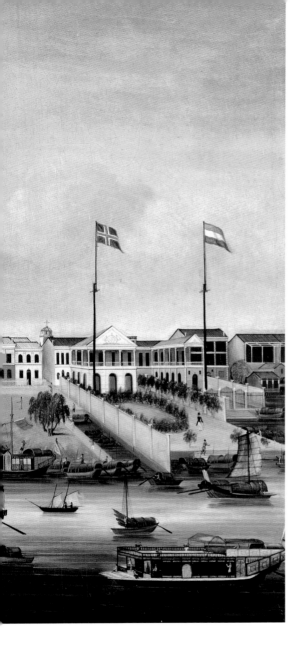

The American ships brought fur pelts in their holds, whereas the British brought opium – thereby turning a Western obsession into an Eastern addiction. The great American traders, however, kept their distance from this practice and prospered nonetheless, becoming their country's first millionaires and, perhaps even more importantly, America's first generation of philanthropists. There would be no New York Public Library as it is today without John Jacob Astor, and no Boston Athenæum without the redoubtable Thomas Handasyd Perkins.

View of Whampoa, c.1830

CHINESE SCHOOL

Oil on canvas, 44.5 x 58.4 cm

Gift via Halcyon Foundation of Dr Dallas Pratt, 1993

1993.172

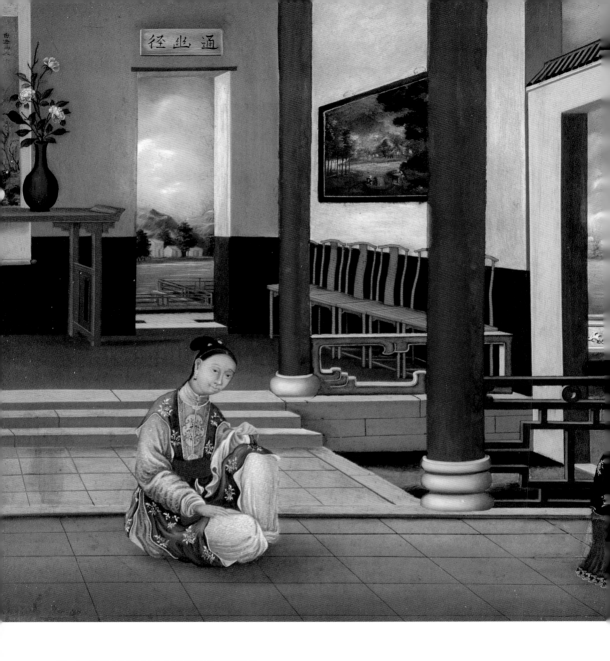

Two Women in an Interior, c.1780

CHINESE SCHOOL
Reverse oil painting on glass, 39 x 52.5 cm
Purchased with funds from Frank and Estise Mauran, 2007
2007.5

THIS SMALL PAINTING is a rich repository of enigmas, ironies and reversals. It represents, in the first place, an interior rather than an exterior view of Chinese life in or near the thriving city of Canton in the late eighteenth century. But the two views are explicitly linked to each other as we gaze through the open doorway at the back of the room – and through the open central door, on the right – and glimpse the docks and houses that lie beyond. The inscription placed above the back doorway informs us that this is a 'pathway for passing into the remote'. This was a common motif in Chinese gardens, and yet there is no garden visible here, only the confrontation of inner and outer, East and West. That external world of hongs and ships is captured in the painting placed (from our perspective) between the two brown columns, a visual reminder of the commerce that produced the luxurious objects, such as this lacquered tea caddy, to be found within the interior itself – all of which could, of course, be exported to the West just as this small painting would be.

The Chinese artist who executed this elegant picture needed, moreover, to produce an image that would please a wealthy Western patron: needed (in other words) to reflect an American or European sense of what was thought to be 'Chinese', thus producing an idealised rather than a strictly accurate view of 'the other'. Would the painting's owners realise that the two elegant women depicted here are actually courtesans? Would they realise that the

process of making and viewing a 'reverse' oil painting re-enacts these very tensions? What we see, as viewers, is a reflection, through glass, of the image painted on the back of this mirror-like object. The artist has had to execute his design in reverse and has had to carry out the painting process in reverse as well, beginning with the foreground and its details before turning to the background. Like this beautiful tea chest, these reverse oil paintings were valued for their elegance and lacquer-like finish.

We, on the other hand, can prize them today for capturing – in their composition and execution – the historical confrontation of East and West.

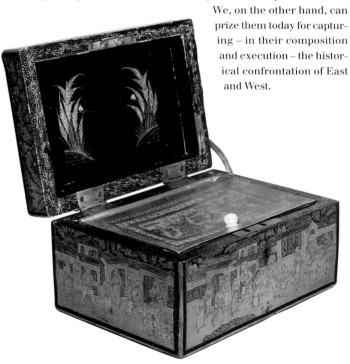

Tea chest, *c.*1820

CHINESE SCHOOL

Lacquered wood, 12.7 x 22.9 x 16.5 cm

Museum purchase, 2004

2004.13

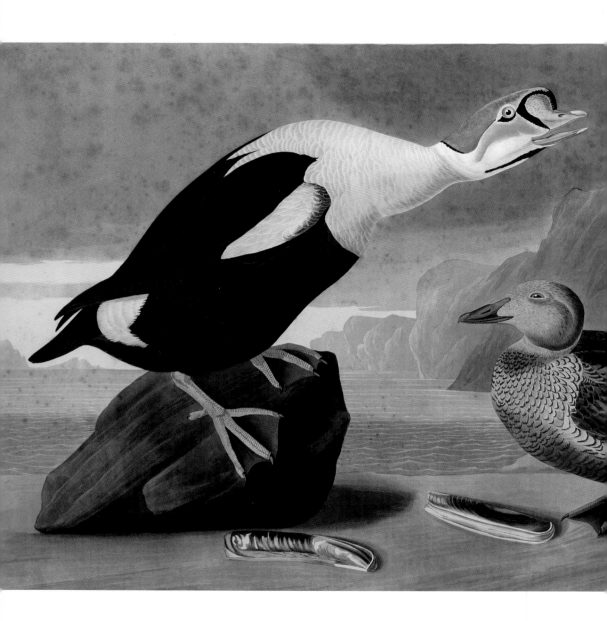

King Duck (Fuligula Spectabilis), 1835

(After) JOHN JAMES AUDUBON
Les Cayes 1785–1851 New York
Engraved, printed and coloured by R. HAVELL, LONDON
Aquatint copperplate engraving on Whatman paper, 63.5 x 89 cm
Gifts of Mrs Alexander Henry Higginson, 1962
1962.190.5

JOHN JAMES AUDUBON nurtured extraordinary ambitions – and he possessed the skills, knowledge and tenacity to transform his journey through the wilds of America into the most sumptuously produced book of the nineteenth century. He wasn't interested in depicting the most prominent American birds: he wanted to paint *all* of them (435 by the time the prints were finally published). And, most famously, he insisted that the images be life-size and that they capture the authentic movements and habits of the birds depicted, as in this print of male and female king ducks with their razor clams. These aspirations dictated pages of an extraordinary size – roughly 30 by 40 inches – and a finished volume that would be immortalised as the 'double-elephant folio'. Born in Haiti and educated in France, Audubon became the most important naturalist of his era, his books devoted to American birds and animals synonymous with the young country's pride in the variety, range and beauty of its wildlife.

The process of generating these accurate and beautiful images was, not surprisingly, both complex and difficult. Although the largest animal conservation society in the United States is named after him, Audubon began his project not just as an artist but as an experienced hunter and a deadly shot. Before the birds could be captured in print, they needed to be stalked, identified, studied, killed, wired into characteristic poses and sketched with graphite and watercolour before their natural hues began to fade. Even with his beautiful watercolours in hand, Audubon needed to find financial backing for his enterprise (he finally settled on a

subscription scheme) and printers who could – through a combination of engraving, etching, aquatint and hand-colouring – bring the birds back to life again. He found his engravers in Reading, and Robert Havell (father and son) did not let their obsessive colleague down, producing images that the book's first viewers must have regarded with a sense of secular revelation. The last two complete sets of the double-elephant folios to be placed on the market have set records as the most expensive books ever sold at auction. John James Audubon would have expected no less.

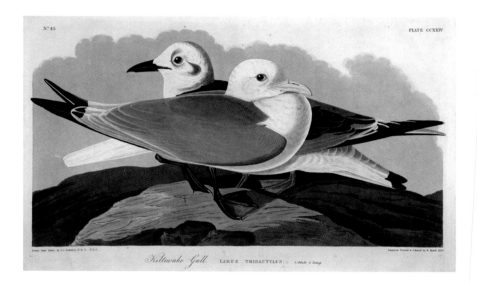

Kittiwake Gull (Larus Tridactyla), 1835

Engraved, printed and coloured by R. HAVELL, LONDON
Aquatint copperplate engraving on Whatman paper, 45.7 x 66 cm
Gifts of Mrs Alexander Henry Higginson, 1962
1962.190.22

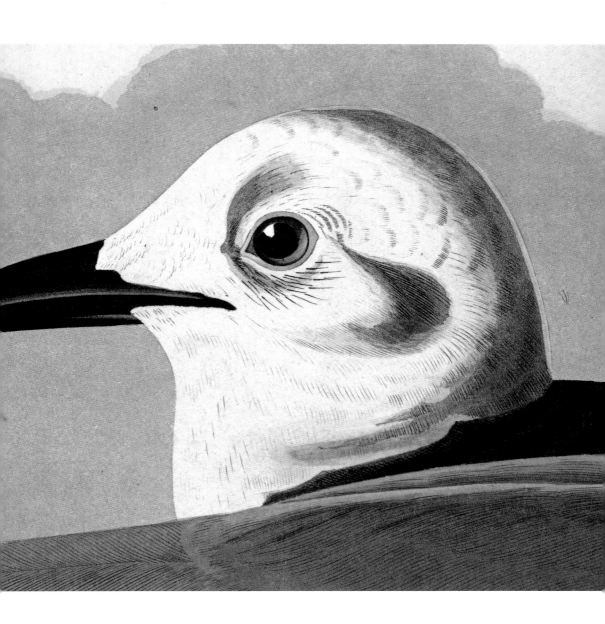

February, 1940

GRANT WOOD
Anamosa, Iowa 1892–1942 Iowa City, Iowa
Lithograph on paper, 43 x 53.3 cm
Bequest of Dr Dallas Pratt, 1994
1994.111

I HAVE ALWAYS HAD A PARTICULAR INTEREST in Grant Wood, having been born and raised in Cedar Rapids, Iowa, where Wood taught at the local high school and lived and painted above the garage of the largest funeral house in the city. I attended Grant Wood Elementary School and later studied in the Grant Wood Room of the old high school. My aunt taught music there while Wood was teaching young men and women how to draw, and she used to tell me that he was so poor that she often brought groceries to the mortuary for him. Many of his paintings are now ensconced in the local art centre in Cedar Rapids, although his most famous picture, *American Gothic*, continues to enjoy its iconic status at the Art Institute of Chicago. Wood had studied in France, but he became a regionalist when he returned to Iowa, working his family, friends and personal history into a taut and muscular, but always sympathetic portrayal of America's heartland. In this lithograph the artist has taken advantage of the soft tonal values of the process –

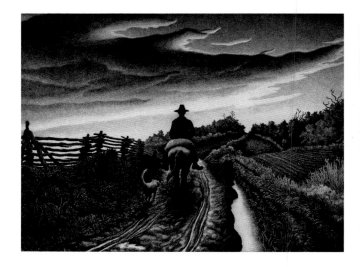

drawing on a stone with a grease pencil – to suggest how the Midwestern winter has blanketed sky and landscape alike, blending the two together and providing a stark contrast with the barbed wire that hems the horses in. Only the horses remain untouched by the snow, and yet their dark profiles reveal the depth of the storm, as does the stylised wave of their manes.

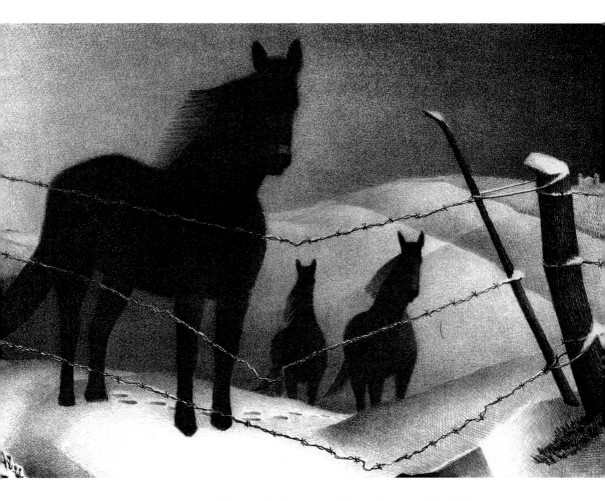

The smaller image, depicting a farmer riding his horse away from his viewers, was executed by one of Wood's colleagues, Jackson Lee Nesbitt, and like Wood's lithograph it belongs in the suite of images collected by the Museum's co-founder, Dallas Pratt, under the general rubric of 'The Compassionate Eye'.

Map of the Western Hemisphere from *Grands Voyages VI*, 1596

THEODOR DE BRY
Liége 1528–1598 Frankfurt
Copperplate engraving on paper, 40.6 x 34.3 cm
Gift of Dr Dallas Pratt, 1989
1988.124

HISTORICAL MAPS AND CHARTS serve as the intersection of contending forces, both when they are made and then later, when they are put to use. We turn to these documents because, among other things, we are interested in the history of exploration, the history of books, the history of book illustration, the history of printmaking or the state of human knowledge at a specific moment. Those who created these maps were driven by a thirst for the dissemination of knowledge, an opportunity to frame the world in an unusual or attractive way, a belief in certain religious or ideological tenets, or simply the need to turn their talents into lira, francs or pounds. Those who attempt to appraise the value or importance of these maps are as often confronted by issues of condition, beauty and rarity as they are by what we might consider the central claim of any historic map, which is to be the first document to disclose the existence of a previously unknown part of the world – or, even more frequently, an increasingly accurate account of it. The American Museum's collection of over 250 Renaissance maps was formed by Dallas Pratt, with all of these multivalent issues in view. He wanted a spectrum of documents that would (literally) chart the growing European knowledge of the New World, and he therefore collected seminal prints that reveal the transformation of map-making from a branch of mythology or religious fervour into one of scientific exactitude. This crucial transition is nicely captured in this map, which – in spite of the explorations it celebrates – reveals a tenuous knowledge of much of the Americas. The four spandrels contain the great explorers themselves (clockwise, from upper left): Columbus, Vespucci, Magellan and Pizarro, each adopting the pose of a theatrical impresario.

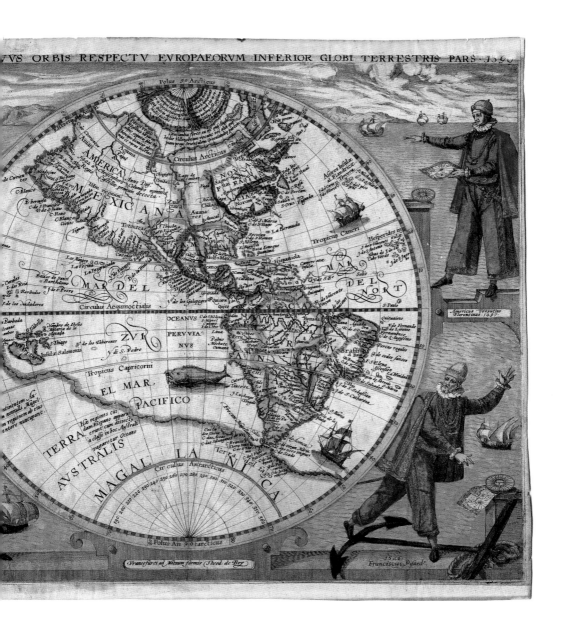

Geronimo (Guiyatle) Apache, 1898

FRANK ALBERT RINEHART
Lodi, Illinois 1861–1928
ADOLPH MÜHR d. 1913
Gold-toned silver chloride print on POP (printing-out-paper)
from a gelatine dry plate glass negative, 30.5 x 25.5 cm
Gift of Mr and Mrs Eric Long, 1980
1980.144

THIS IS THE FACE OF SOMEONE who has seen human misery in all of its guises: someone who remembers and who is himself among the suffering, someone who lost his wife, his three children and his mother in one evening. It is also the face of a man who inflicted his notorious revenge on countless Mexican and American adversaries and their families. Confronted by aggression against his tribe, the Apache, and by faithless agreements with both nations, he became the most infamous Native American in the long history of their displacement and exile. And, I should add, one of the greatest warriors in American history: his Winchester rifle is on display at the United States Military Academy at West Point.

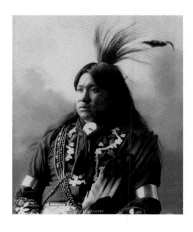

When the photographers Rinehart and Mühr took this portrait at the Indian Congress in Omaha in 1898, Guiyatle ('one who yawns') was 69 years old and still a federal prisoner. Released so that he could attend this meeting, he faces the camera with virtually no appearance of emotion – save, perhaps, those sad, glistening eyes. He is simply and elegantly dressed, with a scarf tied around his neck and carefully folded into the front of his shirt. If we compare his appearance with those of the younger men who posed for Rinehart and Mühr, the differences are compelling, for there is no native iconography here – no plumes, no hat, no material adornment of a face and body that must speak for themselves. These younger men have virtually their entire lives before them, sad (in retrospect) as that may seem to us today. Guiyatle would die 11 years later, following his lionisation by the American public, after being thrown by his horse in the Oklahoma desert.

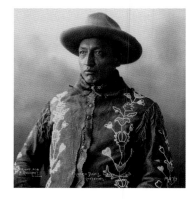

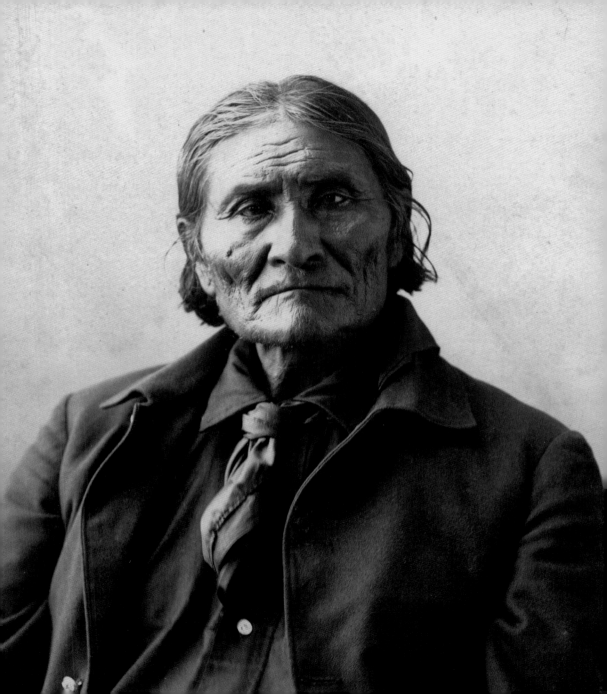

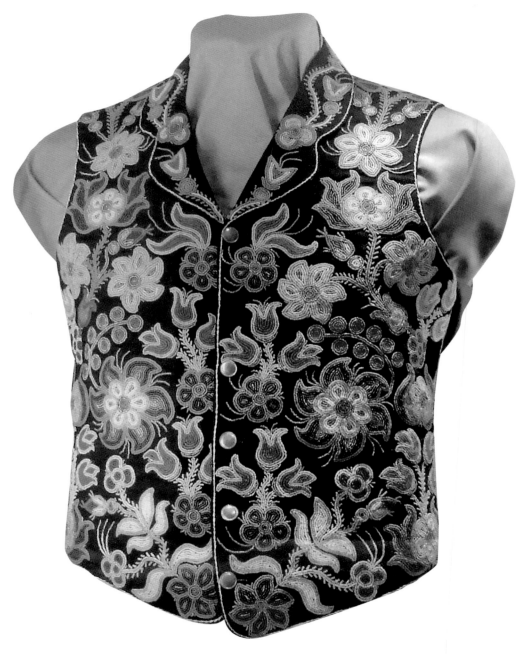

Beaded waistcoat, 19th century

Canadian
Beaded wool, 63.5 x 48.3 cm
Gift of Mrs R. W. Robertson-Glasgow, 1960
1960.181

THOSE TWO YOUNG INDIANS in the previous entry exemplify the different ways in which Native Americans in the late nineteenth century could display their iconic ornamentation. One of them is much more heavily costumed than the other – with beads, a shawl, a kerchief and a silver medallion – but both of them sport the same kind of embroidered floral motifs on the front of their shirts. This pervasive form of decoration is best captured in an extraordinarily beautiful black wool waistcoat that has been embroidered with floral designs in yellow, green, blue and red, all meticulously trimmed with gold beadwork. The waistcoat has brass buttons and, on the back, a muted, symmetrical pattern of mysterious symbols that contrast sharply with the ornate and colourful display on the garment's front. It is thought that these embroidered motifs may have been influenced by early European floral prints, perhaps mediated through French-Canadian convents in the Great Lakes region of North America. A similarly dramatic form of European motifs can be seen in another colourful piece of clothing, a heavily embroidered cap that has its origins in Albania.

The cultural 'translation' of European beadwork to the plains and lakes of North America finds an interesting parallel in the provenance of this particular waistcoat, which was collected by O. P. Skrine, whose family owned Warleigh Manor (easily visible across the valley from the Museum) as well as Claverton Manor itself for many years. Skrine farmed on the Canadian prairies from 1882 until the mid-1890s, when he moved to Vancouver. He returned to the United Kingdom in 1904, and when the American Museum opened in 1961, his daughter presented this handsome object to our co-founders.

Weathervane Indian, *c.*1870

UNKNOWN ARTIST
Gilded copper, 89 x 68.7 x 2 cm
Gift of Dr Dallas Pratt, 1994
1961.20

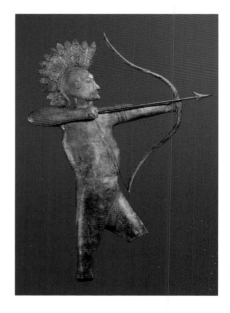

IN THE LAST DECADES of the nineteenth century, decorative weathervanes became a popular feature of the American countryside, adorning the tops of sun-bleached or red-coloured barns while informing farming families of the direction (if not the force) of the wind. Elongated grasshoppers, sailing ships, cantering horses, crowing roosters, flying fish – they were all forged by pressing sheets of copper into moulds and then soldering the pieces together. No American weathervanes are more iconic, however, than those depicting a Native American with his bow and arrow in hand. There are two reasons why this should be so. In the first place, weathervanes are delicate balancing acts. In order to show the direction in which the wind is blowing, the figure must be wider at the back (where it catches the wind's force) and then more slender as it points in the wind's direction. At the same time, the overall figure must be evenly weighted so that it swivels easily on its base, and the outstretched arm and leg of the gilded Indian with his directional arrow perfectly met these requirements. Secondly, the ornamental glorification of the Indian warrior was also a process of domestication. Native Americans had been subordinated, their fierce bursts of retaliation quelled, and the largely white population of the country could therefore live in domestic comfort beneath these useful, totemic figures. American weathervanes have hollowed figures, thus giving them more depth and contour than their European counterparts. The features on this figure are particularly well crafted: note the serrated feathers in his headdress, the dagger and quiver of arrows on his back and the two ornamental bands that grace his upper arms. What a pity that we cannot compare him to the original weathervane, a bronze Triton with forked spear in hand, holding sway over the marketplace in ancient Athens.

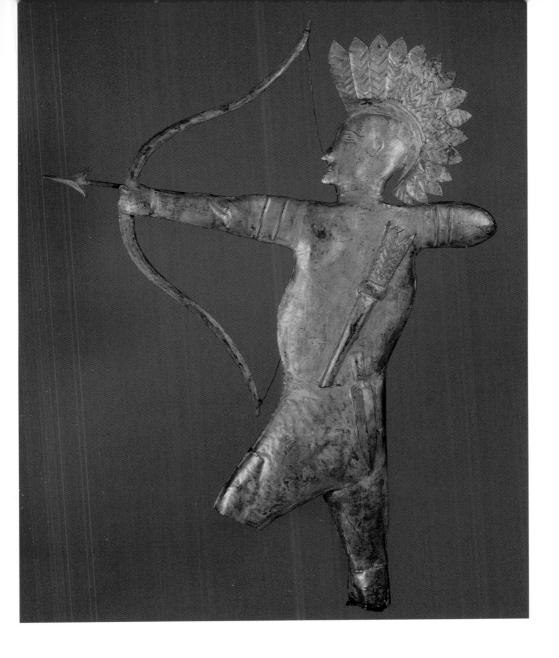

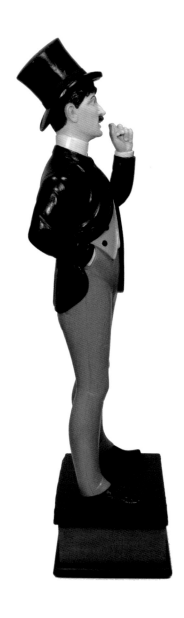

Racetrack tout trade figure, *c.*1890

Attributed to CHARLES PARKER DOWLER
Providence, Rhode Island 1841–1931
Painted and gilded carved wood, 167.5 x 41 x 44 cm
Bequest of Dr Dallas Pratt, 1994
1959.281

THE OPENING of the American Museum's new Folk Art Gallery
– originally the picture gallery of Claverton Manor and later
serving as a billiards room, café and lecture hall – has enabled
us to display our small but world-class collection to great
effect. Arranged against (or mounted upon) handsome crim-
son walls that invoke the elegance of the Regency period,
these pictures and heavily carved objects are meant to assert
themselves as *art* as well as *folk*. Most of them served a com-
mercial or homespun purpose, but that should not blind us
to the artful skill and imagination that created them.

This is especially true of this 'store figure' in the guise of
a racetrack tout, a slick operator who would be equally at
home at a rural fairground or on a riverboat casino plying its
trade along the Mississippi. This type of figure was referred
to as 'The Dude' in recognition of his smooth-talking voca-
tion and dandified appearance. His shiny top hat, jacket,
waistcoat and tightly fitting trousers all enhance the 'slick'
nature of his character, but so do the smaller details as well.
The carefully curled hair and moustache, the squinting left
eye, the slightly mismatched shoes, the gilded stick pin,
signet ring and cufflink: each of these stylised elements helps
to bring The Dude to life. The right hand submerged in his
pocket suggests that he still has something left to disclose.
His raised left hand would originally have held a ticket or
advertisement – an invitation to enter the premises for which
he was the tout. Today he is a silent and empty-handed
reminder of the variety and richness of everyday life on the
sidewalks of almost any American city at the close of the
nineteenth century.

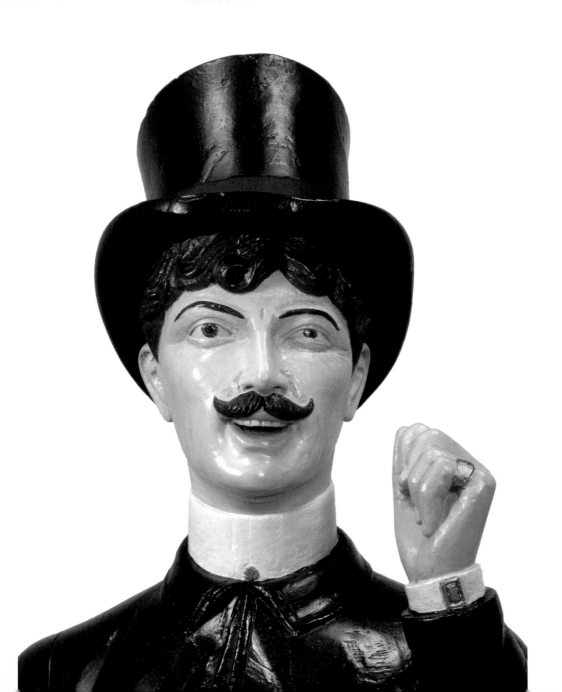

Emma Thompson, c.1850

STURTEVANT J. HAMBLEN
1817–1884 (active Maine/Massachusetts)
Oil on canvas, 68.5 x 56 cm
Halcyon Foundation purchase, 1958
1958.151

THE FOLLOWING TWO PAINTINGS, among the most charming in the American Museum's collections, are related to each other in a variety of ways. In the first place, Prior and Hamblen were brothers-in-law, part of an extended family of painters based principally in Maine. Hamblen's brothers advertised themselves as 'House, sign and fancy painters'; Hamblen, on the other hand, described himself exclusively as a portraitist. Prior, who was 11 years Hamblen's senior, was adept at both portraiture and decorative painting and enjoyed a long and successful career.

For several decades this portrait of a young girl was thought to have been painted by Prior. When the picture was sent to our restorer in preparation for the opening of the new Folk Art Gallery, however, the removal of varnish and of a very old piece of backing board produced two important discoveries. The first was that the painting, although not signed, contained the names of the sitter and her parents on the back of the canvas, and thus we learned that she was 'EMMA THOMPSON'. The second discovery was made by our curator, Laura Beresford, as the dark varnish was carefully removed. Not only was the original colouring much brighter and more vibrant than we could have foreseen – thus producing an even more glowing and sympathetic portrait – but the newly visible level of pictorial detail also enabled us to see how stylistically close the painting is to the very few portraits signed by Sturtevant Hamblen. And thus a 'Prior' became a 'Hamblen' virtually overnight, and Hamblens are much rarer – and rather more highly prized – than Priors.

But what, precisely, is the difference between these two artists beyond the fact that Prior long prospered and Hamblen did not, eventually deciding to enter the gentlemen's clothing business? Both painters executed their work in roughly the same manner, creating a cardboard-like figure silhouetted against a dark and neutral background. There is little (if any) pictorial recession, and shadowing is eschewed in favour of flat colours and a strong

Emma Thompson during cleaning.

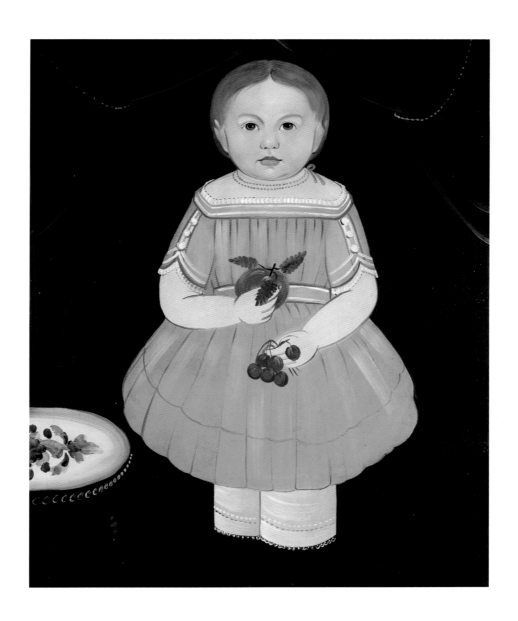

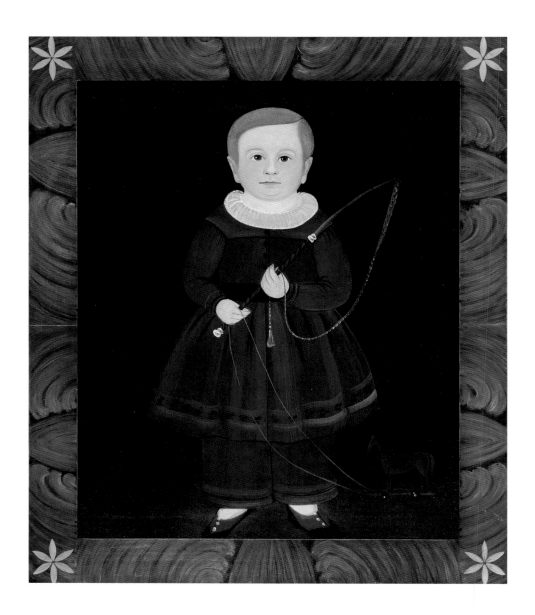

sense of line. At one point Prior advertised his artistry by stating that 'persons wishing for a flat picture can have a likeness without shade or shadow at one quarter price'. He also reduced his pricing for 'side views and profiles of children', and one might argue that what we see in these paintings (including Prior's pendant portrait of a young girl in blue) is a full-profile view that has been rotated to produce a full-frontal portrait. This begins to account, I think, for the eerie stillness we sense in each of these paintings, almost as if the young children have been caught holding their collective breath while sitting for a scissor-wielding practitioner of silhouettes.

The differences between a Prior and a Hamblen are therefore subtle as well as important. The first distinctive characteristic of Hamblen's work is his signature manner of building up form with what Laura Beresford has called 'calligraphic outlines' that slice into drying layers of thinly applied paint. We can see this most clearly in the long brown brushstroke that rounds and unifies Emma's face as it makes its way from ear to chin to ear, and in the more rounded and forceful way in which this process produces Emma's hands and the bend of her elbows. Hamblen's is therefore a more vivacious style of painting, both in colour and in the handling of paint. The second difference between these two brothers-in-law lies in the increased theatricality of

Boy in Blue, *c.*1845

William Matthew Prior
Bath, Maine 1806–1873
Boston, Massachusetts

Oil on canvas, 68.5 x 55.5 cm

Halcyon Foundation purchase, 1958

1958.149

Emma's portrayal. She is pictured in front of red velvet curtains that suggest a rich and dramatic stage set, complete with the painted or embroidered stool that repeats the floral motif in her hands. Prior's children treat their riding whip, book and posy as if they are their rightful possessions, whereas Emma extends her handful of cherries in our direction – refusing to blink or fully smile, but reaching out, at least tentatively, to the viewer.

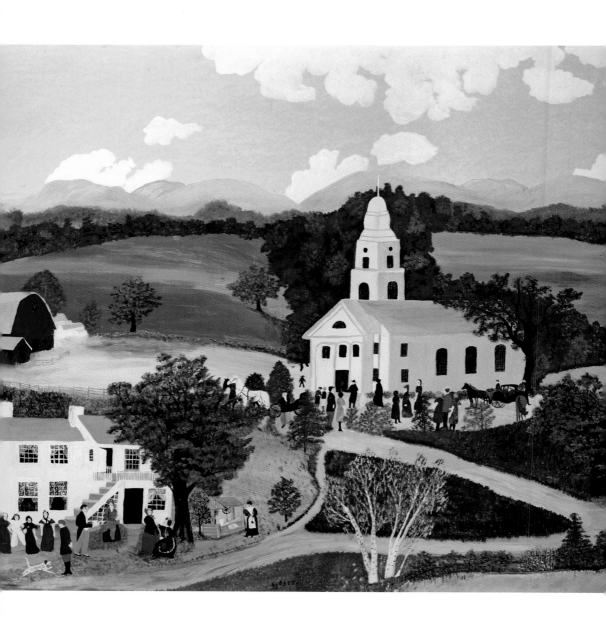

An Experiment with Two Folk Art Paintings

ONE OF THE IRONIES (or contradictions) we discover in folk art and the scholarship it generates lies in the fact that, despite the concerted rush to distinguish the style of these paintings from that of 'academic' art, the paintings themselves often receive short shrift. We learn a great deal about the itinerant artist or the African-American apprentice or the widow who took up embroidery-painting late in life, but what do the pictures themselves have to say?

Let's try an experiment. Let's look closely at one of the paintings that hangs just above the central hallway of the American Museum, a picture that I pass by several times each day. And let's do so by ignoring – at least for the moment – the title of the picture and the identity of the artist. At the very centre of the canvas we find a large, white clapboard church with reddish-brown windows: it's an imposing structure that hovers above the domestic tableaux in the foreground and in front of the green rolling hills in the distance. This is a rural scene that could be indigenous to many parts of the country, but the lavender hills in the far distance suggest that this is northern New England or perhaps upstate New York.

Most of the activity captured in the painting is also centered on this white clapboard building. Two carriages and a horse with its rider have been placed in front and to the side of it, and I can count 15 figures altogether, with another in the distance. Are these good people arriving for the Sunday service or are they leaving it? Given the way in which the figures are clustered, it appears that the parishioners are conversing with each other before making their way home. In the lower right-hand corner of the picture we in fact see a female figure, dressed in brown, conversing with a male figure as she is about to cross the bridge. She's had ample time to walk down the hill, but what do we make of the various figures on the left-hand side? Four women are lined up with their arms entwined; one male figure looks down at an energetic dog; three more women are pictured beneath a tree while a male figure walks towards

them and a servant draws water from a well. Have all of these people – if we don't include the servant – already returned from church? Or have some of them been preparing Sunday dinner within the large house behind them? The answer, of course, is that we will never know. Time stands still. The figures (with one exception) stand still. Even the horses stand still. Even the energetic dog, if you look carefully, seems to be suspended in mid-air.

What is it, precisely, that generates this sense of temporal suspension, this pictorial snapshot of high noon in the Berkshires or the Catskills? First, as we have seen, a relative lack of motion. Second, as you can surmise from my repeated use of the word 'figure', the artist's refusal to depict individuals at the expense of more generalised human types. These villagers wear clothing that bears almost no trace of creases or frills. They are depicted in primary colours that have not been blended or shaded, and their faces bear no distinguishing features whatsoever. They stand in for countless people in countless towns, almost as if they have been carefully placed to 'block' the scene in a film or on the stage. And third, the noticeable lack of foreshortening and geometrical precision that we associate with the classical norms of visual perspective. There is, in other words, no real sense of recession here. The church seems to exist on top of the village rather than behind it, an effect made all the stronger by the relative lack of detail and shading throughout the painting.

Movement, detail, pictorial recession: these artistic choices and directives, which are essential to painting practiced in the academic tradition, are not only superfluous here, but would actually work against the single, central subject of the painting, which is how the church and the domestic rituals surrounding it define a sense of community. Individuality, motion and a carefully structured perspective have been suspended here – rather like that otherwise energetic dog in the foreground. Village life has been frozen in time, perhaps as the artist's attempt to show what it meant to be part of something larger and more timeless than oneself.

The painting I've been writing about was executed by an 86-year-old grandmother who did indeed take up embroidery late in life and then, when arthritis brought that pursuit to a halt, began painting in oil. She was Anna Mary Robertson Moses. She entitled her picture *Service Is Over* in 1946, and she continued to paint until she died at the age of 101, having become a firmly entrenched figure in the landscape of American art.

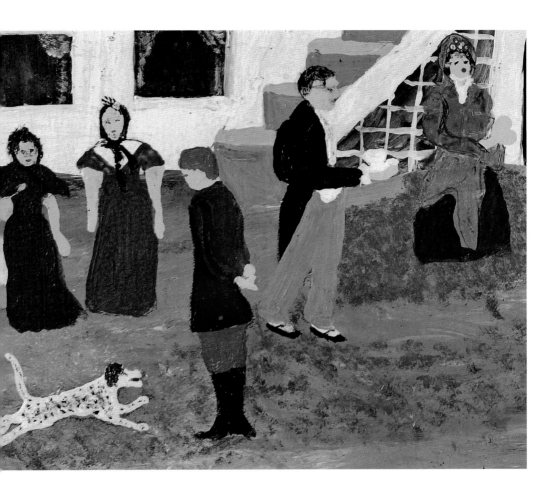

Service Is Over, 1946

ANNA MARY ROBERTSON MOSES ('GRANDMA MOSES')
Greenwich, New York 1860–1961 Hoosick Falls, New York
Oil on board, 63.5 x 90 cm
Gift of Margaret P. Mallory, 1984
1984.162

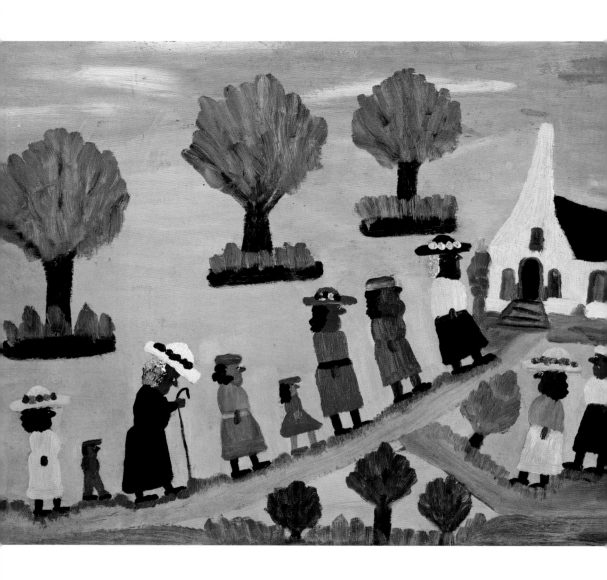

Now take a moment to compare her composition with the painting illustrated here. There is remarkable consistency between them: in the choice of subject, in the flat application of paint, in the unmixed primary colours, in the lack of pictorial recession and in the relative universality of the figures depicted. This second scene, which is clearly of people *arriving* at church, was painted by Clementine Hunter, not terribly well-known in her own lifetime but increasingly, after her death, seen as an important chronicler of the African-American experience in the rural South. If anything, Hunter's composition is even more stylised than Grandma Moses'. Notice how the figures walk *on top* of the paths rather than within them, how the trees in the foreground are also not allowed to intrude on these walkways, how the figures tower over the little door to the church and how the church itself appears to be built directly against the tan-coloured field. Clementine Hunter knew those fields quite well, for she had laboured in them for decades. As she once quipped, 'paintin' is a lot harder than picking cotton. Cotton's right there for you to pull off the stalk, but to paint you got to sweat yo' mind.'

Hunter's depiction of Sunday morning in the South is also a celebration of community – but a community of a different kind. Church brings these people together in their Sunday finest, but they do not interact with one another. These figures, mostly women, make an almost solitary pilgrimage to their place of worship. And all the people here are, of course, black. This is a segregated community within a much larger, still uneasily integrated community, with no visible communication between them. What we have, in other words – without protest, without anger – is 'community' with a difference, much like the inverted 'C' with which Clementine Hunter decided to sign her distinctive work.

Going to Church, *c.*1960

CLEMENTINE HUNTER
Cloutierville, Louisiana 1886–1988 Melrose, Louisiana

Oil on board, 43.2 x 63.5 cm

Gift via Halcyon Foundation of Robert Wilson, 1970

1970.5

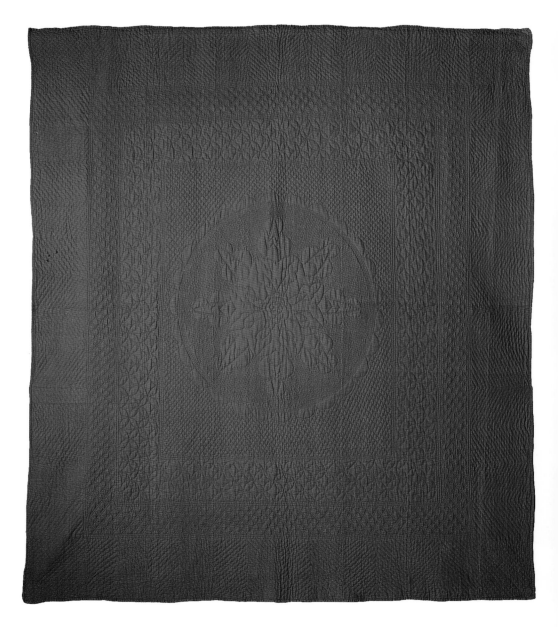

Red whole-cloth quilt, 1775–99

Quilted cotton and linen twill, 211 x 191 cm
Bequest of Dr Dallas Pratt, 1994
1962.22

'QUILT' IS BOTH A VERB AND A NOUN, both the process of finishing a coverlet and the finished textile itself. Quilts have three separate layers: the backing material that lies on the bottom, the wadding that is placed in the middle to give the quilt its warmth and – for lack of a better word – its distinctive puffiness, and the fabric on top, which may range from just a few pieces of matched cloth (as in this example) to a kaleidoscopic collage of different fabrics that have been stitched to each other. Quilting is the stitching process that holds these three layers of fabric together, ranging over the entire surface of the textile and thereby producing its various patterns. On whole-cloth quilts such as this one from the late eighteenth century, quilting is the *only* form of decoration to be found, which means that the

intricate needlework must carry the entire aesthetic burden by itself. This example in a rich red colour features a central floral design that is entirely picked out by hand, surrounded by an architectural frame that is in turn enclosed by squares with strong parallel lines. This beautiful quilt was probably dyed after the final stitch-work was complete, giving it an even saturation of colour.

In the American imagination, quilts are as much a part of popular culture as motherhood, apple pie and the Fourth of July – but American quilts inevitably have British origins, just as British quilts find their progenitors on the Continent and, ultimately, in the Far East. This particular quilt bears a strong resemblance to textiles produced in Wales, where a passion for quilting remains just as keen as in England and the United States.

Chalice quilt, *c.*1860

MADE BY SLAVES ON THE MIMOSA HALL PLANTATION, Marshall, Texas

Pieced and quilted cotton, 221 x 191 cm

Gift via Halcyon Foundation of Mrs W. Webster Downer, 1983

1983.172

QUILTING IS CLOSELY ASSOCIATED with communal enterprise and communal spirit, perhaps most piquantly captured in the ritual of the sewing or quilting 'bee', which suggests a veritable hive of communal activity. In the nineteenth century, young women were expected to begin making their own quilts long before they actually married, but the quilts in a trousseau could only be finished by other hands. Women often worked on their quilts while the men in their families were engaged in another practical and symbolic ritual, the day-long process of barn- or house-raising. It was also common practice for women to produce quilts that were symbols of friendship, and it is not unusual to find quilts whose sections have been autographed by all of the women engaged in creating them. But we have to be careful to remind ourselves that, like Clementine Hunter's procession of Sunday-morning church-goers in the rural South, not all of these communities were of their own making. One of the American Museum's most famous quilts has just such a complicated history. The chalice quilt illustrated here was created as part of an annual ritual when the Anglican bishop of New Orleans would visit remote areas of Texas and Louisiana to perform baptisms and weddings. The quilt was

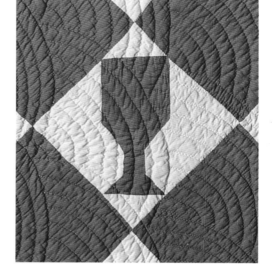

presented to him for his use during such a visit, but it was created by the slaves living on the Mimosa Hall Plantation, to whose use it would be donated once the bishop had departed. This quilt therefore points in two directions at once, the chalice symbolising both the eminence of the spiritual figure making his annual rounds, and the subjugation – the cross they must bear – of those who so meticulously produced it.

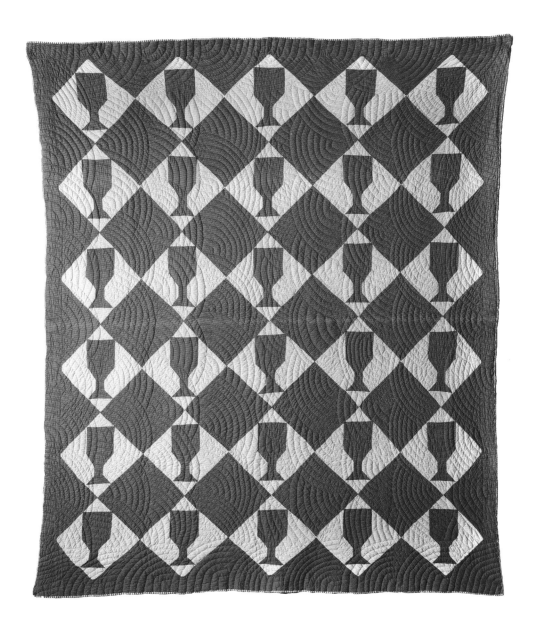

Cigar silk ribbon quilt top, *c.*1880

Silk ribbons, 104 x 104 cm
Halcyon Foundation purchase, 1964
1964.338

QUILTING is a painstaking and time-consuming process, dependent upon an eye for detail and a skilled hand for stitching. Examined at a distance, however, that intricate handiwork may not immediately be apparent to us as we are struck by the powerful or complicated design of the finished textile itself. Many quilts were clearly intended to produce what we today might call a 'wow' factor, especially in the dramatic play between vibrant colours and strong geometrical patterns. If the *craft* of quilting is based on an ability to produce minute, spidery stitches, the *art* of quilting is based on an ability to engage the work of the hand in the service of a much larger and equally complex enterprise. For me, the fascination of quilts and quilting lies precisely in this aesthetic interplay between the minute and the general. In this exquisite example made from the silk ribbons used to wrap bundles of cigars in the late nineteenth century, many of the individual ribbons have been decorated with a feathery embroidery stitch. The overall design of the textile is also intricate, and its theatrical geometry may well mask – at least at first glance – the more subtle flourishes to be found within it. The quilt is a 41-inch square that contains four progressively smaller squares – unless, of course, you count the squares that have been covered over or, even more intriguingly, follow the trajectory of the diagonal corners as they form several more squares beyond the confines of the quilt itself. Many American men of the time (including, presumably, our smooth-talking Dude on pp. 54–55) were fond of their cigars; many American women collected the colourful silk ribbons in order to produce pillows, table coverings, quilts and – appropriately – the smoking caps and jackets that were worn as part of this masculine ritual.

The Development of 'Old Glory', c.1892

JAPANESE SCHOOL

Cotton and silk embroidery, 110.49 x 64.8 cm
Museum purchase, 1975
1975.61

IT'S DIFFICULT TO DECIDE precisely what to call this
embroidered panel. I'm tempted to describe it as a sym-
bolic or narrative work because of the way in which the
visual elements spiral outward from the centre of the
design and, in so doing, invoke a rather broad swathe
of American history – 400 years' worth, to be exact. The
pictorial structure of the design is surprisingly complex.
The dark blue cloth that serves as the background con-
tains three separate elements: the flag in the centre, the
ferocious eagle clutching the rod from which the flag
hangs and an inscription at the bottom that reads 'The
Development of "Old Glory".' The design in the centre
of the flag is also three-fold. On the outer edge is a dis-
play of Colonial and American flags that are spread out
almost like a deck of cards, beginning with the cross of
St George in the lower left-hand corner and culminat-
ing with Old Glory at the lower right. Within this display
of flags is a 'wooden' surround that contains a star, two
sets of entwined flags and a mysterious object at the
bottom that seems to be some form of cot or litter.
Finally, within this cartouche is a tableau of Christo-
pher Columbus making his claim upon the New World,
and this central feature enables us to determine the
textile's date, which is presumably quite close to the
400th anniversary of Columbus's arrival in the Ameri-

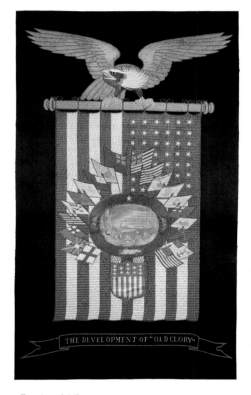

cas in 1492. This date is supported by the design of the large flag in which
these various elements are embedded. This version of Old Glory displays
42 stars, and although such a flag never existed, it is very close to the 43-
star version of 1890 and the 44-star version created when Wyoming joined
the Union in 1891.

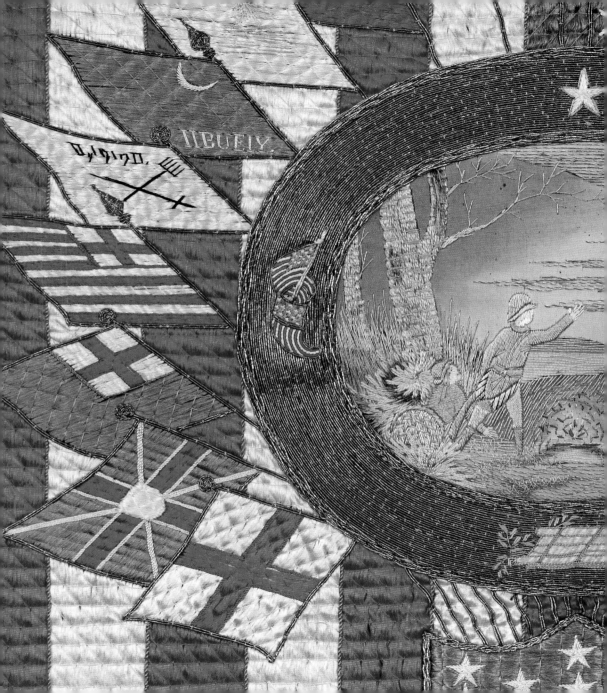

Abraham Lincoln, 1991

ANGELA CONNER
London 1935

Cast bronze, 76 x 44 x 56 cm

Halcyon Foundation purchase with funds from the Claverton Theatre Club, 2011

ONE OF THE AMERICAN MUSEUM's most recent acquisitions, this monumental bronze bust of Abraham Lincoln is not in the least diminished by being placed at some distance from the manor house, just where the manicured lawn begins to fall away into the arbours and trails that lie directly below it. The statue serves, in fact, as a cultural magnet, drawing visitors down from the terrace so that they can literally touch the massive head and walk around the limestone base. The bust is the creation of Angela Conner, one of the most distinguished sculptors practicing in England today. She has sculpted the heads of the royal family and the Dukes of Devonshire, writers and prime ministers, and many of the actors who have trodden the boards of London's West End. Most of those busts are life-size, however, whereas this statue measures two and a half feet in height, as if time and tragedy have augmented what was a large and imposing visage in the first place. Her bust of Lincoln represents one of the few posthumous heads Conner has sculpted; she was compelled to do it, she told me, because of a haunting story Lincoln once told about being able to see both his current face and a pale, deathly version of it in the same mirror. Conner also creates extraordinarily large pieces of sculpture for public sites that are closely fused with the natural elements – wind and water in particular – that swirl around them and often generate their articulated movement. Articulate: it's an unusual word to associate with the stony silence of statuary. And yet here, in the presence of this beautifully executed head, one may be pardoned, I think, for acknowledging the dignity and pathos expressed in Angela Conner's work.

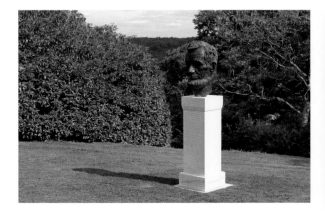

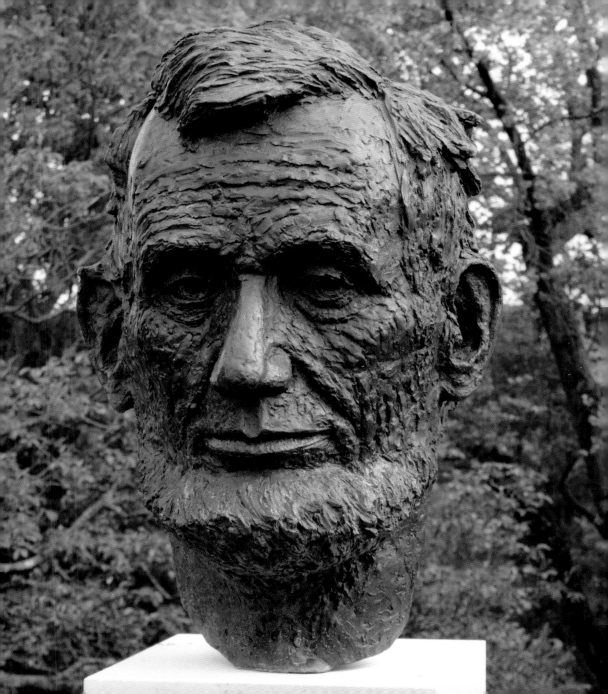

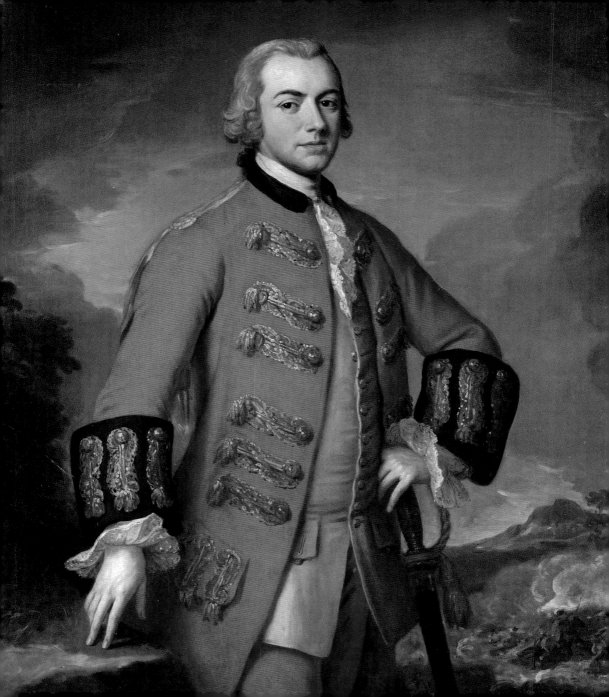

General Sir Henry Clinton, *c.*1765

Attributed to ANDREA SOLDI
Florence 1703–1771 London

Oil on canvas, 124.3 x 100.5 cm

Gift via Halcyon Foundation of Henry S. Williams, 1964

1964.70

AS WE HAVE SEEN, not all of the treasures at the American Museum are American, although they all enjoy a relationship of one kind or another to the American colonies or to the first 100 years of the American republic. This portrait, for instance, depicts a British military officer who, if he had had his way, would have prevented the American colonies from ever becoming an independent republic in the first place. Our painting of a blue-blooded Englishman has, moreover, been attributed to the hand of an Italian artist working in London, although this traditional attribution stands as yet another of the puzzles this portrait has engendered.

We're on safest ground if we begin with Sir Henry himself, who became one of Britain's most prominent soldiers during the final quarter of the eighteenth century. Born in 1730, he was the son of Admiral George Clinton, who served as the Royal Governor of New York in the 1740s. Henry joined his father in 1743 and was probably educated on Long Island before taking his military commission at a very early age and serving, with distinction, throughout the Seven Years' War. He joined Generals Robert Howe and John Burgoyne in Boston during the War of American Independence, distinguishing himself during the British victory at Bunker Hill in Charlestown in 1775. Two years later, when General Howe left for Philadelphia, Clinton was placed in charge of New York; and when Burgoyne was captured at Saratoga and Howe returned to England (in 1778), Clinton was made Commander-in-Chief of the British forces in North America. In January 1780 Clinton commanded troops that captured Charleston, South Carolina, but he then returned to England in 1782 after Lord Cornwallis capitulated at Yorktown. Henry Clinton was made a Knight of the Bath in 1776; late in his career he was appointed Governor of Gibraltar, although he died in 1795 before sailing from London.

Ascertaining whether this handsome and beautifully coloured portrait is indeed a likeness of Henry Clinton has not been a straightforward propo-

sition. The painting was previously owned by Harold S. Williams of New York City, who wished to present it to the newly opened institution in memory of one of the Museum's two founders, John Judkyn, who had died in 1963. Both Dallas Pratt (our other founder) and the Museum's first director, Ian McCallum, were eager to provide the painting with a suitable home, but the Museum's archives reveal that their interest was primarily stirred by the possibility that the portrait had been painted by a prominent American – and ideally, of course, by the peripatetic Gilbert Stuart, whose artistic star has never dimmed on the continent General Clinton had attempted to save for George III. As Pratt wrote in a letter to Clinton's biographer, William Willcox, in 1964, 'The American Museum would very much like to possess

a Gilbert Stuart, a Gilbert Stuart of Sir Henry Clinton, or a portrait of Sir Henry Clinton by another artist, but we do not think it appropriate to display a portrait of some unknown British officer of the 18th century, no matter how attractively painted by an Italian (?) portrait painter.' As we shall see, Dr Pratt had the third of his three wishes fulfilled.

Very few portraits of Clinton have survived, even though he sat to Reynolds and must have been an attractive figure throughout the 1760s and 70s. Fortunately, a label attached to the back of the frame indicates that the picture had been lent by the Duke of Newcastle to a portraiture exhibition in London in 1867 – and this made sense because Clinton was closely related to the family. Then, in the early 1960s, the late Duke of Newcastle found a catalogue in his family records with a description of a painting which exactly matched the portrait that had been offered to the Museum. The catalogue identified the sitter as General Sir Henry Clinton and mentioned that the picture had been lent to an exhibition in London in 1867. (It was eventually sold when the Newcastle collection was dispersed at the Clumber sale in 1937.)

But who actually painted this particular portrait? The Newcastle catalogue attributed the painting to William Hoare, who practiced in Bath for many years, and Hoare was known to have painted members of the Newcastle family. But the English art historians who advised Dallas Pratt and Ian McCallum suggested that the picture was probably the work of the Florentine artist Andrea Soldi, who was a fashionable and successful portraitist in London from his arrival around 1736 into the 1760s, when this portrait was presumably executed. Although this picture has not been included in the only modern consideration of Soldi's work, such an attribution continues to make sense given the lack of another strong contender, its characteristically well-drawn head, its bravura treatment of the officer's coat and gold trimmings and the relative precision of its modelling (in comparison with the contemporaneous work of Ramsay and Reynolds, who were often engaged in a much grander style). The portrait, in short, has many of the Italianate features that characterised Soldi's work when he was at his very best. Perhaps the strongest testimonial came from his contemporary, George Vertue, who wrote in his notebook in 1751 that Soldi's portraits 'are freely & well drawn & his colouring true and very natural. he is certainly a painter of superior merit in the portrait way'.

This edition © Scala Publishers Ltd, 2012
Text © Richard Wendorf
Illustrations © The American Museum in Britain

First published in 2012 by
Scala Publishers Ltd
Northburgh House
10 Northburgh Street
London EC1V 0AT
www.scalapublishers.com

In association with The American Museum in Britain
www.americanmuseum.org

ISBN: 978 1 85759 772 1

Project editor: Sandra Pisano
Design: Nigel Soper
Printed and bound in Italy by Studio Fasoli

10 9 8 7 6 5 4 3 2 1

FRONT COVER: Unknown artist,
Weathervane Indian,
c.1870 (see pp. 52–53)

PP. 2–3: Anna Mary Robertson Moses
('Grandma Moses'), *Service Is Over*, 1946
(see pp. 60–63)

BACK COVER: Chinese School, *View of
Whampoa*, c.1830 (see pp. 34–35)